ITN
The ROYAL YEAR 1993

PHOTOGRAPHED BY TIM GRAHAM

MAGNA BOOKS

This edition published 1993
by Magna Books, Magna Road,
Wigston, Leicester, LE18 4ZH, U.K.

Copyright © 1993 by Tim Graham

All rights reserved. No part of this publication may be reproduced, stored in a retrieval system, or transmitted, in any form or by any means without the prior permission in writing of the publisher, nor be otherwise circulated in any form of binding or cover other than that in which it is published and without a similar condition including this condition being imposed on the subsequent purchaser.

ISBN 1-85422-523-5

Designed and typeset by Martin Bristow

Edited by Fiona Holman

Printed and bound in Hong Kong
by Paramount Printing Group Limited

For G and G (Maura and George) with love

Page 1: The Queen's youngest grandchild, Princess Eugenie, daughter of the Duke and Duchess of York, at the wedding of Alison Wardley, her former nanny. Title spread: The band of the Scots Guards processing down the Mall during the official welcoming ceremony for the state visit of the President of Portugal. Right: The Princess of Wales, President, Royal Marsden Hospital, at the Royal Albert Hall, London for the Liza Minnelli gala tribute to Sammy Davis Jnr.

*Above left: The Princess Royal as President of the National Federation of Young Farmers' Clubs, attended the Worcestershire Young Farmers' Golden Jubilee Ball on 4 July.
Above right and right: The Princess of Wales being greeted by well-wishers during her visit to Greater Manchester on 6 July.*

THE ROYAL YEAR • 5

6 • THE ROYAL YEAR

*Facing page above left: On 7 July the Princess of Wales, as Patron of the Benesh Institute, attended a gala evening by the Australian Ballet at the London Coliseum.
Above right: The Prince of Wales visited Mudchute Park and Farm on the Isle of Dogs in London on 8 July.
Facing page below left: As Chancellor of Salford University, the Duchess of York attended the degree ceremony at the University on 9 July.
Below right: Princess Alexandra arriving for a gala performance of* Anything Goes *by the London Academy of Music and Dramatic Arts.*

Right: The Duchess of York presented prizes in aid of a children's charity, Angels International, at the Royal County of Berkshire Polo Club on 10 July.

Facing page: The Prince of Wales took part in the Cartier International Polo Day, the highlight of the British polo season, at the Guards Polo Club, Smith's Lawn in Windsor Great Park on 26 July, where (above) the Queen traditionally presents the prizes.

THE ROYAL YEAR • 9

*The 92nd birthday celebrations of Queen Elizabeth the Queen Mother took place at her London home, Clarence House, on 4 August. The Queen Mother was accompanied, as has become the custom, by close members of her family as she came out to greet the waiting crowds.
Left: The Queen Mother with the Prince and Princess of Wales and Prince Henry.
Below: (from left to right) Princess Margaret, the Queen, Viscount Linley, the Prince of Wales, the Queen Mother, the Duke of York, the Princess of Wales, Prince Henry and Lady Sarah Armstrong-Jones.*

10 • THE ROYAL YEAR

Right: The Queen at Portsmouth before embarking on the Royal Yacht Britannia *at the start of her annual summer cruise to the Western Isles of Scotland.*
Below: The Queen with Prince Edward as Britannia *prepares to leave Portsmouth.*

THE ROYAL YEAR • 11

12 • THE ROYAL YEAR

Facing page above left: The Queen on a wet day at Scrabster, a small fishing port on the northern coast of Scotland, which is close to the Queen Mother's Aberdeenshire home, the Castle of Mey.
Facing page above right: The Queen at Aberdeen having disembarked from the Royal Yacht Britannia *for the drive to Balmoral.*
Facing page below: Reviewing the guard at Balmoral at the start of the Royal Family's annual summer holiday in the Highlands.
Right: The Queen Mother waiting in the rain at Scrabster to greet the Queen and the rest of the royal party as they came ashore from Britannia.

THE ROYAL YEAR • 13

Below and right: The Princess Royal and her son, Peter Phillips were at their Gloucestershire home, Gatcombe Park on 22 August for the British Open Horse Trials Championship. This year was the 10th anniversary of these successful horse trials which are organized by Captain Mark Phillips.

14 • THE ROYAL YEAR

Right: On 2 September Prince and Princess Michael of Kent helped their son, Lord Frederick Windsor move into his boarding house for his first day at Eton College, Princess Michael making sure he has plenty of tuck for the first few days.
Below: A family group at Eton – Prince and Princess Michael of Kent with their children, Lady Gabriella and Lord Frederick Windsor.

THE ROYAL YEAR • 15

16 • THE ROYAL YEAR

Facing page far left: The Princess of Wales accompanied by her lady-in-waiting for the day, her eldest sister, Lady Sarah McCorquodale, on a visit to Nottingham with the Prince of Wales on 9 September.
Facing page left: The Duchess of York collecting Princess Eugenie (right) and her cousin, Zenouska Mowatt, Princess Alexandra's granddaughter, from the Winkfield Montessori school on 11 September.
Facing page below: The Duchess of Gloucester at the official opening of the Leicester Disablement Services Centre at the city's General Hospital on 15 September.

Left: The Princess of Wales, Patron of British Red Cross Youth, visited the Red Cross National Headquarters in central London on 17 September where she toured an exhibition on the suffering in Bosnia and Somalia, two of the world's worst humanitarian crises.
Below: The Princess of Wales wore cheerful pink for a busy but wet day of engagements in Cleveland, north England on 23 September.

THE ROYAL YEAR • 17

18 • THE ROYAL YEAR

*Facing page: On 25 September, a rainy autumnal day, the Princess Royal attended the Queen Elizabeth's Foundation Race Day at Ascot while the Duke of York played golf at the Peper Harow Golf Day at Wentworth, Surrey.
Above left: The Princess of Wales at the gala premiere of* Just Like a Woman *at the Odeon Cinema, Leicester Square on 24 September.
Above right: The Princess of Wales visited the West London Day Centre for Single Homeless and Rootless People on 28 September.
Right: At the Railton Road Methodist Church, Brixton in south London on 5 October to launch the Joint Council for Anglo-Caribbean Churches' Drug and Alcohol Abuse Project.*

THE ROYAL YEAR • 19

*Above left: A former soldier himself, the Duke of Kent still takes a keen interest in army affairs. On 16 September the Duke visited the Army School of Ammunition at Kineton in Warwickshire to open the Felix Training Centre, the most advanced of its kind in the world for training bomb disposal operators.
Above right: The Duchess of Kent presented the Lloyds Bank British Fashion Awards at the Grosvenor House Hotel in central London on 12 October.
Left: The Princess Royal, as President of Save the Children Fund, attended a gala Summer Fun Day at Hanbury Manor Hotel, Thundridge in Hertfordshire.*

*Right: The Princess Royal, Chancellor of London University, opened the new Randall Institute at King's College on 13 October and during her visit saw at first hand several research projects concerning molecular and cell biology in the science and technology laboratories.
Below left and right: The Prince and Princess of Wales went to Westminster Abbey on 14 October for a service of thanksgiving to commemorate the 50th anniversary of the Battle of El Alamein, which marked the turning-point in the fight against the Nazis in World War II. The Prince of Wales wore the uniform of Colonel-in-Chief of the Cheshire Regiment while the Princess wore a stunning Catherine Walker-designed silver-grey outfit and matching hat.*

THE ROYAL YEAR • 21

THE STATE VISIT TO GERMANY

19 – 23 October 1992

The state visit to Germany by the Queen and the Duke of Edinburgh, the third of her reign, was the first since the country's reunification in 1990. This was also the first visit by the Queen to former Communist parts of Eastern Europe.

Right: The state visit began with talks and lunch at the Villa Hammerschmidt in Bonn with President von Weizsäcker.
Below: The following day the Queen and Prince Philip visited the Chancellor, Helmut Kohl at his official residence, the Federal Chancellory bungalow.
Facing page: The Queen and Prince Philip at the state banquet given in their honour at Schloss Augustusburg near Bonn.

THE ROYAL YEAR • 23

*Above left: On 21 October the Queen and Prince Philip, accompanied by the Federal President of Germany and the Mayor of Berlin, made a historic walk through the Brandenburg Gate in Berlin into the old Communist sector, setting foot for the first time in former East Germany. The Brandenburg Gate was Imperial Germany's triumphal arch and later became the best known symbol of a divided Europe as it was just east of the infamous Berlin Wall.
Above right: During the visit to Berlin the Queen visited the Oberspree Cable Factory, the largest British investment project in Berlin.
Right: The Queen on her historic visit to the city of Dresden in former East Germany for a Service of Reconciliation and Remembrance at the Kreuzkirche. The city had been badly damaged by the RAF in 1945, when in one of the worst bombing raids of World War II over 35,000 people died.*

*Facing page above: The Queen and Prince Philip walking through the terraced gardens of Sans Souci Palace in Potsdam.
Facing page below: The farewell to President von Weizsäcker at Schloss Bellevue in Berlin at the end of the state visit.*

24 • THE ROYAL YEAR

THE ROYAL YEAR • 25

TOUR OF KOREA BY THE PRINCE AND PRINCESS OF WALES

2 – 5 November 1992

During the four days' official tour of Korea the Prince and Princess of Wales carried out a busy schedule of engagements, the Prince of Wales concentrating on business forums and seminars and the Princess on her work for charity.

Right and below: Arriving at Seoul Airbase for the official ceremonial welcome to Korea which included the colourful Chitadae band.
Facing page above: Children in Korean national costume presenting the customary flowers of welcome on their arrival.
Facing page below: Leaving the airbase in the official limousine.

26 • THE ROYAL YEAR

*Left: The Prince and Princess of Wales at Gloucester Valley where they laid a wreath to the 'Glorious Gloucesters' Memorial.
Below and facing page: The Princess of Wales at the Presidential banquet given in the royal couple's honour by President Roh of Korea.*

28 • THE ROYAL YEAR

Facing page far left: The Princess of Wales visiting the British School in Seoul.
Left: Attending a performance of Coppelia *by the Scottish Ballet at the Sejong Cultural Centre.*
Above left and right: The Princess of Wales at the Maeree Deaf and Dumb School in Ulsan where she painted her name on a china bowl in the pottery room.
Above right: After Korea the Prince of Wales spent three days in Hong Kong where he attended the Remembrance Day ceremony at the Cenotaph.

Right: The Queen at the opening gala concert of the Festival of Scandinavian Arts at the Barbican Centre in London on 10 November.

In November the Princess of Wales paid an informal and highly successful visit to France, mainly to support the Lille Arts Festival whose theme in 1992 was Britain and the Commonwealth, as well as pursuing her interest in humanitarian organizations. Left and facing page above left: As part of the Princess's promotion of British goods abroad, the Princess's stay in Paris included a visit to the recently opened Conran shop in the 7th arrondissement. Facing page above right: The Princess of Wales was guest of honour at a dinner organized at the Palais d'Orsay by the Minister of Health and Humanitarian Aid. Right: From Paris the Princess travelled to Lille in northern France where she was given a civic welcome by the Mayor at the Hôtel de Ville.

THE ROYAL YEAR • 33

34 • THE ROYAL YEAR

Facing page: The disastrous fire at Windsor Castle which began on 20 November in the private chapel quickly spread to the state apartments in the north-east corner of the castle. It took firemen over two days to put out the flames. Right: The Queen inspecting the fire damage on 21 November. Below: The charred beams and damaged walls of historic St George's Hall, the scene of many lavish state banquets, as it appeared after the fire.

Right: On 24 November, only a few days after the terrible fire at Windsor Castle, the Queen went to the Guildhall for a luncheon given by the Corporation of London to mark the 40th anniversary of her accession to the throne. It was during this luncheon that the Queen made her moving speech about her 'annus horribilis'.
Below left: The Princess Royal, as Chief Commandant of the Women's Royal Service, visited Gutter Tor Refuge on Dartmoor, Devon.
Below right: The Princess of Wales at the Royal Variety Performance at the Dominion Theatre, London on 7 December.
Facing page: At 92 the Queen Mother's zest for life is well known and she still carries out a formidable list of official engagements, including being the guest of honour for the National Federation of Far Eastern Prisoners of War Clubs and Associations given by the Corporation of London on 8 December.

36 • THE ROYAL YEAR

THE ROYAL YEAR • 37

Left: The Queen and the Princess of Wales arriving at the wedding of their friend, Harry Herbert, the youngest son of the Earl of Carnarvon, the Queen's racing manager.
Below left: The Princess of Wales, Patron of the Chicken Shed Theatre Company, leaving the Place Theatre, central London on 14 December after a gala performance in which 300 young people took part.
Below right and facing page: As Patron of the National Children's Orchestra, the Princess of Wales attended a concert at the Queen Elizabeth Hall, central London on 20 December.

THE ROYAL YEAR • 39

Christmas Day service at the Sandringham parish church in West Norfolk.
Left: Prince Philip, Prince Edward and other members of the royal family walk from Sandringham House to church.
Below left: The Queen receiving flowers from well-wishers after the church service.
Below right: Viscount Linley and Lady Sarah Armstrong-Jones returning to Sandringham House.
Facing page above: The Queen and Princess Margaret outside the church lych gate.
Facing page below: The newly-wed Princess Royal leaving church on Christmas Day with her husband Commander Timothy Laurence and her daughter Zara Phillips.

40 • THE ROYAL YEAR

THE ROYAL YEAR • 41

42 • THE ROYAL YEAR

The Duchess of York took her daughters, Princess Beatrice (below left and far below) and Princess Eugenie (below right) for a New Year skiing holiday to the Swiss Alpine resort of Klosters.

THE ROYAL YEAR • 43

Right: The Princess Royal, President of the Royal Yachting Association, opened the 1993 London International Boat Show on 6 January.
Below left: As Patron of the National Association of Victims Support Schemes, the Princess Royal attended a charity performance of the Bolshoi Ballet at the Royal Albert Hall, London.

Below right and facing page above: On 13 January the Duke of Edinburgh, International President of the World Wide Fund for Nature, and Prince Charles paid a visit to the Shetland Islands off the north coast of Scotland to inspect environmental damage caused by the wreck of the oil tanker Braer.
Facing page below: The Queen and Queen Mother paid a visit to the West Newton Women's Institute during their traditional New Year holiday at nearby Sandringham House, the Queen's private home in West Norfolk. The Queen Mother is branch president and has been a member for 56 years.

44 • THE ROYAL YEAR

THE ROYAL YEAR • 45

Previous spread and above left: The Duchess of York, Patron of the Combined Services Winter Sports Association, posing with competitors at the association's Alpine Championships at Altenmarkt in Austria.
Above right: On 9 February Prince Charles, Patron of the International Tree Foundation, planted the first of a copse of lime trees in Green Park, central London to mark the fortieth anniversary of the Queen's accession to the throne.
Left: Prince Charles, President-elect of the Royal College of Music, greeting the Queen Mother that afternoon as she arrived at the College for a concert to mark her adoption as President Emerita.

48 • THE ROYAL YEAR

Above left: Prince Philip, President of the Central Council of Physical Recreation, visited the Community Sports Leaders Award Scheme Action Day at the John Orwell Sports Centre, east London on 10 February.
Above right: The Queen visited the All Souls Clubhouse in central London on 11 February.
Right: The Princess of Wales visited South Yorkshire on 17 February.

50 • THE ROYAL YEAR

Facing page far left and below: Prince Edward accompanied President Herzog of Israel during his inspection of the Coldstream Guards at Buckingham Palace on 24 February.
Facing page left: The Princess of Wales carried out engagements in south-west London on 25 February.

Left and below: The Queen and Prince Philip went to Newbury, Berkshire on 26 February for various engagements, including a visit to St Bartholomew's School.

THE ROYAL YEAR • 51

THE PRINCESS OF WALES VISITS NEPAL

2 – 6 March 1993

The tiny kingdom of Nepal set in the spectacular foothills of the Himalayas was the setting for the Princess of Wales's first official overseas tour since her separation from the Prince of Wales. Nepal is one of the world's poorest nations and the tour's emphasis was on work, rather than sightseeing.

Right: At Tribhuvan International Airport in Kathmandu the Princess of Wales received greetings and garlands from five little virgins representing the Nepalese goddess Kumari, a Nepalese custom accorded only to high-ranking visitors. Below left: As Patron of the British Red Cross Youth, the Princess of Wales visited the Nepal Red Cross Office where she signed the visitors' book. Below right: At Kathmandu airport where the Princess boarded a helicopter for a journey up-country with Baroness Chalker, the Minister for Overseas Development who accompanied her to visit several projects funded by British aid. Facing page: At Budhanilkantha School.

52 • THE ROYAL YEAR

54 • THE ROYAL YEAR

*Facing page: The Princess of Wales at the memorial for the victims of the Pakistan Airlines flight which had crashed six months earlier in Nepal.
Right: At a private dinner hosted by King Birendra of Nepal.
Below: In the village of Panauti to visit a Nepal Red Cross project.*

THE ROYAL YEAR • 55

At Panauti with Baroness Chalker, the Minister for Overseas Development.

56 • THE ROYAL YEAR

Right: Prince Edward, on behalf of the Queen, attended the Commonwealth Day Observance Service at Westminster Abbey on 8 March.
Below: In the week celebrating International Women's Day the Princess of Wales went to Southwark in south London to open the Riverpoint Hostel for Single Homeless Women.

Right and below left: The Princess of Wales on walkabout outside Bolton Hospice during a day of engagements in Greater Manchester on 17 March. Below right: The Princess of Wales, Patron of Centrepoint Soho, arriving at the Queen Elizabeth II Conference Centre in central London on 18 March.

THE ROYAL YEAR • 59

The Cheltenham Festival Meeting, including Gold Cup Day, takes place in mid-March and is the highlight of the National Hunt season and the winter racing calendar. The Queen Mother, a keen supporter, invariably attends (below left), as does the Princess Royal, seen here with her husband, Commander Timothy Laurence and (facing page, centre) Brigadier Andrew Parker-Bowles.

THE ROYAL YEAR • 61

*Left: Prince Henry at Zurich airport on his way to the Austrian resort of Lech for a skiing holiday with the Princess of Wales, Prince William and a group of friends.
Below: The Princess of Wales on a chairlift with Prince William and her friend Kate Menzies.
Facing page right: The Princess of Wales brushing snow off Prince Henry's ski boots.
Facing page far right and below: The Princess of Wales and the two princes enjoyed a horse-drawn sleigh ride to a local restaurant for supper one evening.*

THE ROYAL YEAR • 63

Above and left: The Princess of Wales and her sons, Prince William (above left) and Prince Henry (above right) setting off for a day's skiing.
Facing page: While the Princess of Wales was at Lech in the Austrian Tyrol the Duchess of York and the two princesses were not far away in the Swiss resort of Klosters. On the first morning of their holiday the Duchess posed for photographs on the slopes.

THE ROYAL YEAR • 65

*The traditional Maundy Thursday service, which continues the centuries-old tradition of the monarch distributing alms or Royal Maundy to the poor, took place this year on 8 April at Wells Cathedral in Somerset.
Above left: The Queen arriving at the cathedral with the Bishop of Bath and Wells.
Left and above right: Crowds of well-wishers greeted the Queen after the service.
Facing page: The Queen and Prince Philip at Wells Cathedral.
Overleaf: The official photograph outside the cathedral after the service. Attending the Queen are the children of the Royal Almonry carrying traditional nosegays of sweet herbs and the Queen's Bodyguard of the Yeomen of the Guard who play an important ceremonial part in the service.*

66 • THE ROYAL YEAR

THE ROYAL YEAR • 67

70 • THE ROYAL YEAR

Facing page above left and right: The Queen and Queen Mother, escorted by Prince Philip, leave St George's Chapel, Windsor after the traditional Easter Day service. Facing page below left: The Princess of Wales and the Hon. Sir Angus Ogilvy, President, exchange affectionate greetings during the Princess's visit to the Imperial Cancer Research Fund headquarters on 15 April. Facing page below right: That evening the Princess of Wales attended the gala première of the film, Accidental Hero.

Above left: On 21 April the Duchess of Gloucester, Patron of the Iris Fund for the Prevention of Blindness, attended a performance by Opera Interludes. Above right: On 23 April Princess Michael of Kent attended a performance of The Merry Wives of Windsor to celebrate the reconstruction of the Globe Theatre. Below left: The Duchess of Kent presenting prizes at the 'Doctor of the Year' Award luncheon on 22 April. Below right: The Princess of Wales at the official opening of the Egyptian House for Productive Families on 22 April.

THE ROYAL YEAR • 71

On 24 April the Princesses Eugenie and Beatrice were bridesmaids at the wedding of their former nanny Alison Wardley who was marrying a former royal bodyguard, Ben Dadey. Above left and right: The princesses arriving at the bride's home to change for the wedding. Left: Princess Beatrice and Princess Eugenie outside the church. As well as floral headdresses the bridesmaids carried Victorian-style hoops of flowers. Facing page: The Duchess of York with her daughters after the wedding.

72 • THE ROYAL YEAR

The traditional carriage procession from Victoria Station to Buckingham Palace at the start of the President of Portugal's state visit on 27 April.
Left: The Queen and President Soares.
Below left: The Prince of Wales.
Below right: Princess Margaret and the Duchess of Kent.

74 • THE ROYAL YEAR

The Duke of York took command of the minehunter HMS Cottesmore *on 27 April at Portsmouth. The new captain said of his appointment, 'I think the greatest ambition of any officer in the Navy is to command his own ship. I'm extremely privileged and pleased to take command of one of Her Majesty's ships.'*

Facing page: The Princess of Wales, Patron of the drug-related charity Turning Point, visited the Home Office on 29 April for a briefing on more than 400 projects under the Home Office's Drug Prevention Initiative.
Above left: The Princess Royal, President of the Royal Trust for Carers, visited Greenwich in south London on 28 April to open London's first Carer Centre.
Above right: That evening the Princess Royal, Patron of the Home Farm Trust, attended the film premiere of The Mystery of Edwin Drood *accompanied by her husband, Commander Timothy Laurence.*
Right: Princess Michael of Kent, Patron, at the Sparks Auction dinner at the Carlton Tower Hotel in London on 28 April.

THE ROYAL YEAR • 77

THE QUEEN AND PRINCE PHILIP VISIT HUNGARY

4 – 7 May 1993

The four-day state visit to Hungary was the Queen's first to a former Warsaw Pact country and she was given an enthusiastic welcome by the crowds. After two days of more formal engagements in the capital, Budapest, the Queen and Prince Philip travelled to the Great Hungarian Plain to see some of rural Hungary.

Above: The Queen and Prince Philip at the official welcoming ceremony in Budapest on 4 May.
Left: The exchange of official presents between the Queen and President Göncz took place at the main Government Guest House, where the royal party stayed.

Facing page above left: The Queen leaving the Hungarian Parliament on 6 May after addressing the Hungarian National Assembly.
Facing page above right: Prince Philip at the picnic lunch organized for the royal party in Bugac, an area of the Great Hungarian Plain famed for its traditional farming and horse-breeding.
Facing page below: The Queen at the picnic lunch in Bugac. In honour of her Hungarian hosts the Queen wore a Kucsma-style hat for the day of engagements in the Great Hungarian Plain.

THE ROYAL YEAR • 79

80 • THE ROYAL YEAR

Facing page: In Bugac the Queen and Prince Philip watched a display of Hungarian horsemanship which is renowned throughout the world.
Right: The Queen and Prince Philip arriving at the Ethnographical Society in Budapest for the Return State Banquet given in honour of their Hungarian hosts.
Below: The Queen and Prince Philip, on walkabout in Vorosmarty Square in Budapest on the last day of the state visit, received a rapturous welcome from the crowd.

THE ROYAL YEAR • 81

*This season Prince Charles has moved down from high- to medium-goal polo which is a less time-consuming version of the sport. He now plays for the Maple Leafs, a team sponsored by his Canadian friend Galen Weston. Far below: Polo is a fast, exciting and sometimes dangerous sport and during a match on 9 May at Smith's Lawn, Windsor Great Park the Prince of Wales came a cropper.
Below left and right: On a weekend leave from school, Prince William and Prince Henry came to watch the match.*

Right: The Princess of Wales, President of the Hospitals for Sick Children, visited Great Ormond Street on 10 May and as she left she was presented with a posy of flowers by an Opthamology outpatient, Omah Hunter, aged 8, from north London.
Below: At the International Social Service Spring Fair, organized each year by the wives of London's Diplomatic Corps, the Duchess of Kent was greeted by diplomats' children wearing traditional costumes from their own lands.

THE ROYAL YEAR • 83

The Royal Windsor Horse Show takes place in mid-May in the spectacular setting of the Home Park at the foot of Windsor Castle. This page: The Duchess of York took Princess Beatrice and Princess Eugenie to the fun-fair adjoining the Horse Show. Facing page: The Queen attends the Horse Show, always accompanied by members of the royal family (here, Prince Edward) and is a keen supporter of Prince Philip who takes part in the carriage-driving events.

84 • THE ROYAL YEAR

THE ROYAL YEAR • 85

Prince Charles's official visit to Poland between 17 and 20 May was a hardworking trip and an important contribution to promoting British business in the country.
Left: On his first day in Warsaw the Prince met the President of Poland, Lech Walesa at Belvedere Palace.
Below: Inspecting the guard of honour at the official welcoming ceremony.
Facing page above: On the second day of his visit the Prince of Wales laid a wreath at the Warsaw Uprising Monument which commemorates the 1944 Warsaw uprising against the Nazi invaders.
Facing page below left: The last engagement in Poland was the Prince's tour of Majdanek concentration camp where the Nazis murdered over 360,000 inmates during World War II. A desolate spot, little has been altered at the camp since 1944, and the Prince was visibly moved during his walk around the gas chambers and mass execution ditches.
Facing page below right: Prince Charles at a wreath-laying ceremony at the Westerplatte Memorial in Gdansk.

86 • THE ROYAL YEAR

THE ROYAL YEAR • 87

On 30 May the Prince and Princess of Wales put on a public display of togetherness when they attended a service held at Liverpool's Anglican Cathedral to commemorate the 50th anniversary of the Battle of the Atlantic. As the wind played havoc with the Princess of Wales's hat and skirt the Prince and Princess had a good laugh together.

*The Derby is one of the world's most famous horse-races and Derby Day this year took place on the 40th anniversary of the Queen's Coronation.
Included in the royal party at Epsom Racecourse were (left) the Prince of Wales, (facing page above left) Princess Alexandra and (facing page above right) Prince Philip, seen here with the Earl of Carnarvon, the Queen's racing manager.
Facing page below: Watching the racing from the Royal Box were (from left to right) the Queen Mother, Lord Carnarvon, the Queen, Michael Oswald, the Queen's stud manager, and the Prince of Wales.*

THE ROYAL YEAR • 91

Trooping the Colour is the colourful ceremony held each year in June to mark the sovereign's official birthday.
Right: This year the Queen Mother travelled to Horse Guards Parade in Whitehall with Princess Margaret.
Below: The Queen leaving Buckingham Palace for Horse Guards Parade in her phaeton. The Prince of Wales and Prince Philip can be seen riding behind the Queen.
Facing page above: Included in the royal party on the Palace balcony to watch the spectacular RAF flypast down the Mall was royal bride-to-be, Viscount Linley's fiancée, the Hon. Serena Stanhope (left) who wore a stunning, fashionable, broad-brimmed hat for her first appearance on a big royal occasion. Standing between her and Viscount Linley is Lady Sarah Armstrong-Jones, his sister.
Facing page below: Other members of the royal family with the Queen on the Palace balcony included the Queen Mother, the Queen, Prince Philip and the Duke and Duchess of Kent.

THE ROYAL YEAR • 93

*After Trooping the Colour the royal party assembled on the balcony of Buckingham Palace to watch the RAF flypast.
Facing page above: Princess Margaret, the Queen Mother and the Duchess of Kent.
Right: Lady Gabriella Windsor with her mother, Princess Michael of Kent.
Below: (from left to right) the Hon. Sir Angus Ogilvy, Princess Alexandra, Princess Margaret, the Queen Mother, the Hon. Serena Stanhope, the Queen, Prince Philip, the Duchess of Kent, the Duke of Kent, Prince Charles, Lady Gabriella Windsor, Princess Michael of Kent, the Duchess of Gloucester and Lady Romsey.*

Right and below left: Wearing a glamorous, body-hugging black evening dress, the Princess of Wales was guest of honour at a gala dinner on 10 June to launch the renovation appeal for the Serpentine Gallery in Kensington Gardens, London.
Below right: The Princess of Wales carried out engagements in Cambridge on 17 June.

96 • THE ROYAL YEAR